HANDED DOWN
The Artisan Tradition

HANDED DOWN
The Artisan Tradition

Photographs, Oral Histories and Introduction
by Barbara Traisman

Carolyn Bean Publishing, Ltd.
San Francisco

Cover photograph: Bob Guglielmi and Virgil Antolini, *ironsmiths*

The photographs of Harvey Egbert (page 33) and Antonio Andreatta
(page 6) were previously published in *Witness to Our Times*,
Aperture Photocommunications, 1977.

The photographs of Harvey Egbert (page 33) and Pat Morello (page 51)
were previously published in *Combinations, A Journal of Photography*, 1978.

The photograph of Andrew Fisher (page 21) was previously published
in the *San Francisco Chronicle*, December 1979.

The photograph of Barbara Traisman (page 82)
is by Pamela Valois.

Designed by Barbara Luck and John Carroll, Carolyn Bean Associates, Incorporated

First edition published 1980
First printing September 1980
Printed in the United States of America

Carolyn Bean Publishing, Ltd.
120 Second Street
San Francisco, California 94105

Library of Congress Catalog Card Number: 80-67829
ISBN: 0-916860-07-8

This book is for my father, Ed Traisman,
who taught me the value of meaningful work.

Contents

Acknowledgements

I would like to extend a warm thank you to the artisans, without whose trust and good will this book would not have been possible.

Many thanks also to Ann Senechal for her fine editing job; to Catherine Hoover for her appreciation of the historical aspects of the work; and to Pamela Valois and Mary Pitts for their discriminating observations about the photographs.

And last, to Jim Lorenz for his special understanding of the spirit of the project, for his sustained encouragement while it was in progress and for the many other things he did to help, a very special thank you.

Introduction

This body of work is intended to be a collective portrait of a group of people whose way of life is passing. They are the old artisans. Once a group that had many members, their ironworking, silversmithing and other skilled shops were common elements of most towns and cities. They are a class that has traditionally been established for generations in an area. It is made up of people whose grandparents came to America from the "old country" and brought their skills with them and set up artisan shops. The people I have photographed and interviewed in most instances learned the crafts and joined the businesses at an early age and continued to work in the old-world tradition all their lives. Now, as they are about to retire, in many cases there are no children to leave the businesses to because they have become truckers or lawyers or auto mechanics.

There is an ambience of timelessness about the shops. We can easily imagine the artisans themselves in a setting of a much earlier time. Many of the work techniques haven't changed substantially for a hundred years or more. Machinery has been added here; materials have been substituted there, because, for example, flax is no longer available for sails, canvas must do. But the spirit and sensibility with which the work is done are elastic and span the time that has passed from the "old days" to the present.

They are a group that is shrinking in size, and there is a palpable sense of history and passing about those who are still here. We can already see them as part of the past and are surprised to find that they are still current and vital. I photograph a barrel maker and in his face and manner he reminds me of my grandfather. Or is he of an even earlier age? After he is gone, he joins that whole group of others who were also artisans in the old way. And while he lives and works, he has behind him the lineup of all those other craftspeople, fixing him somehow in a unique scheme that is old and now fragile.

One of the special things that happened as I met and photographed these artisans, was the development of a recollection process that was connected in some way with the images. I began to realize that photographs take on an added dimension when they start to remind us of things which are passing or have passed. Associations, memories, emotions are evoked by certain images and forms. A feeling of familiarity or recognition can be produced by an image that doesn't have an exact equivalent in one's own experience.

As the images began to activate the recollection process in me, I wanted to know more about the people I was photographing. Questions about them kept coming to mind. Were they consciously aware of the heritage of their skills and trades? How important was that heritage? Did they view themselves as islands of quality in an increasingly shoddy and impersonal market place? What accounted for the ease and dignity of their demeanor? And most of all, were they as satisfied as they appeared to be?

While doing this twofold portrait, first the photographs and then the interviews, I encountered consistent good will among the artisans. My method of making the photographs was simply to show up at an interesting-looking shop which I had scouted out on my own or, even better, one that I had learned about from an artisan I had already photographed. I would ask, "Do you have a friend who has a shop as interesting as yours is?" And he would say, "Oh yeah. You go see Larry Fambrini. He's got a great little place off Mission Street." And I'd be directed to a tiny alley named Washburn, to which I'd travel four blocks from an equally tiny alley named Juniper. Many of the places would have been hard to find if I hadn't gotten directions and suggestions.

What began to emerge was a sense of a real and tightly knit community of people who worked in similar or related trades, who were friendly with each other, and who called each other to collaborate on jobs that needed, for example, both iron and brass work. They knew of each other's successes and hard times, and congratulated or commiserated accordingly.

From time to time, friends slipped away from the scene. An example is the story of a highly skilled wireworker who for years had a shop that was very well located. Virgil Antolini, an ironsmith who knew him, said, "He decided to move to Oregon, and we were all flabbergasted when he told us he was moving out of the city. His friend Lawrence, who knows him well, said, 'You're cuckoo. This is where the money is and you've got such a good following.' But I don't know; I guess sometimes people just get disgusted. So you go out to the country. There's open air and all that, but when you leave a big metropolis, the demand is not there. If you have a community like this, you have it." As it later turned out, because of a sudden illness, the wireworker had to close his shop in Oregon and sell off his inventory of ornate leaf work and other highly specialized items, many of which are no longer being made.

2

Although these craftspeople were busy and hard-working, and often pressed for time to get their jobs out, they showed a relaxed willingness to put down their work in order to be photographed or interviewed, often on very short notice. They took being photographed seriously and posed with a blend of dignity and ease.

When I contacted them for the interviews, some of which took place almost two years after the photographs were made, I encountered the same friendly openness, as though I'd seen them only a few weeks earlier. And I was impressed by their stability; with a few exceptions, they were still there. No one had been transferred or had changed jobs or been laid off.

A definite sense emerged from the interviews that their stability becomes more and more fragile as time passes, as society and its values change, and the economic environment becomes less and less hospitable to small business. Perhaps the physical stability becomes augmented by a psychological intact-ness. Many of them see their passing way of life as already part of the "old days," as they fondly refer to the past. From a point of view that has remained constant and focused by the continuity of their work, they view change philosophically. With some sadness, but mostly with objectivity and resilience, they regarded changes that made their lives harder or more tenuous as being, " just part of today's world. You have no alternative. You gotta follow it."

One gets a sense of merging of present and past ways of being. The energetic older woman who for many years ran the shoemaking shop on the corner and viewed life with an uncluttered wisdom, is a fixture of our childhood memories. But at a certain point, at certain times, memory blurs the lines of distinction and she becomes the wise old woman, who happens also to be a shoemaker. She grows old and closes her shop, but her image is so developed that she remains in our minds; we recognize in her the qualities of an archetype that becomes increasingly important as the pace of change accelerates around us.

It is easy to anticipate a time in the not-too-distant future when there will be very few of these artisans left. There will be generations of people who won't remember artisans as a familiar part of the community. One senses the loss of quality that we would experience without them—not just quality of workmanship, but, in a larger sense, the quality of life as it once was. In many ways, these artisans are representatives from a more stable period in our society, when a feeling of community was more developed. They remind us of a way of life perhaps best associated with how it felt to live in a time when people didn't lock their doors, when they lived their lives more simply and slowly. Will those who have never known these things feel an inexplicable sense of loss and of something missed and missing? Without these and other connections to the past, will they feel an underlying uneasiness about the future, an uncertainty about the direction of their lives?

3

This sort of confusion doesn't seem to trouble these artisans. Rather, as an apparent result of having engaged in a lifetime of work that is self-expressive and skilled, these people appear to have become through the ageing process integrated and confident, at ease with themselves in the world. They are not the "elderly," but instead suggest the elders, who, by their example, have helped provide psychological reference points for us.

Barbara Traisman
Berkeley, California 1980

*"The work was in the home environment
and little by little you started.
It's like inheriting something from your parents."*

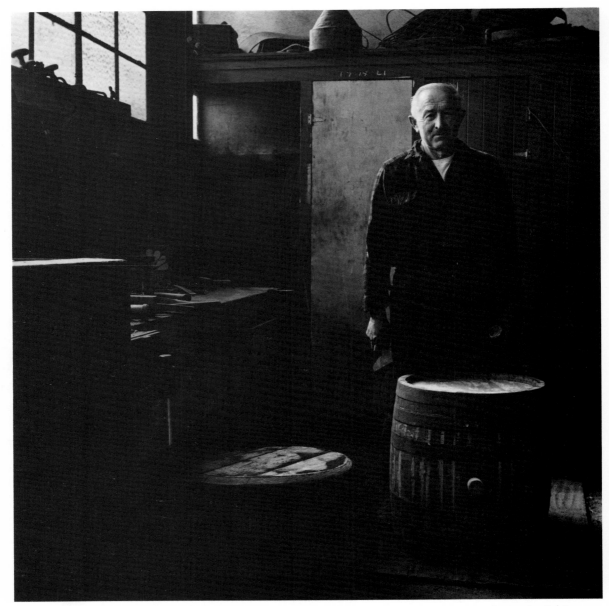

Antonio Andreatta

The old days, they don't come back no more. I started workin' inside a cooper shop as an apprentice in 1933, in the Bay View district in San Francisco. Thirty-six years I worked there.

In those days, everything used to be in barrels. Pickles, vinegar, mustard, wine, olive oil. Now it's all in metal or plastic. It's not so good. Pickles don't age in plastic like they do in wood. Now a new barrel costs you a hundred dollars. Wood is so expensive they hardly make new ones. When a barrel breaks, instead of fixing it, they cut it in half and use it for planters. Don't need no more the cooper.

Back then you did all kind of work. Every morning we'd light the boiler to get steam to clean the barrels. We used to paraffin them, load up the truck, deliver the ones we fixed, pick up a new load to take back to the shop. So many places we used to go to get the barrels. Every day we'd go to Hiram Walker to get a load.

Hand cooper is hard work; you gotta go fast. Everybody had a bench, like a horse. One guy here, one guy there, about fifteen men. Each man had a number, and you put it on the barrels you fixed. If something on a barrel leaked, they sent it back to you. Each morning you had to fix your tools so they were nice and sharp. We had a cooper's union in 1930, and guys made six dollars a day. Some of them were very good, strong men from the old country. Germany, Yugoslavia, Italy. They knew how to make anything, even the tools. Some of them on Sundays would work on a boat. The hull of a boat is a lot like a barrel. Some knew how to make a house, too.

Libby, Heinz, S & W all used to put their food in barrels. S & W had a cooper shop in Redwood City with three or four men working all the time, and they had thousands of barrels. Every week we would repair for them. Same thing for Swift. They had a cooper shop, too, and now Swift is all torn down. Juliani, an Italian company that made vinegar, used to

Antonio Andreatta
cooper

7

send their stuff to Italy in barrels. Every month we'd go down to Front Street and pick up a couple hundred barrels. When the coopers were working, on the freeways you'd see trucks loaded with barrels as high as they could go.

The place I'm working now ain't got much work. The boss can't find many barrels. A few vineyards still use barrels and need work from a couple of coopers, but not many. Distilleries use steel tanks now. Sometimes we make hot tubs special for people.

I been there about eight years, and when there's no work there, I go work out in my back yard. I try to make the best of things. If I'm working for somebody, I like to do a good job, produce. Sometimes the boss says to me, "Easy Tony, easy."

My father used to work in a coal mine in Texas. When I was three, he and my mother took me back to the old country. We lived on my grandfather's farm close to Venice for fifteen years. North Italy was beautiful—nice country. They grew corn, wheat, grapes. If I'd stayed in Italy I would be a cooper, too. But it's better here. This is the best country there is.

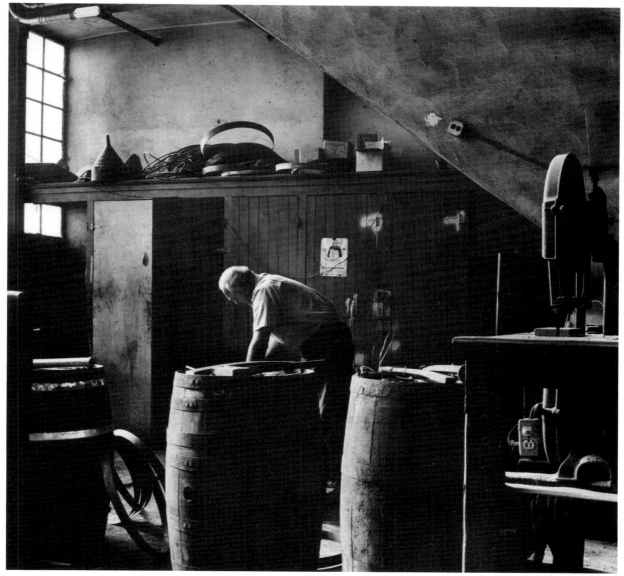

Antonio Andreatta

Frank Passa
violin maker

You might say I grew up in my grandfather's little violin shop. I was there all the time. Since the old man couldn't see too well, I was the shop eyes, and my earliest job was pulling splinters out of his fingers. When he wasn't around I was constantly fussing with his tools, nicking his saws, hitting nails with them. I was forced to learn how to sharpen those tools before he found out. So my first skill was in trying to conceal my roughness in handling his tools. I must have been about seven or eight, and I would also take cigar boxes and try to make holes in them and put strings on them.

My grandfather came to this country from Palermo around the turn of the century as a cabinet maker and an instrument maker. The instrument making kind of phased out since there were many more demands for cabinets. There wasn't much demand for musical instruments in America because the Europeans were the ones making them, and they were brought in for peanuts. He couldn't make a living from instruments, so he made them out of love.

My father went into the building trade. He was a younger fellow so he could climb the buildings and put up beams. He was a real builder, and construction was the best trade you could go into when America was being built.

I made my first violin under my grandfather's supervision. I was around eleven and was going into a full size violin and couldn't afford to buy one. I built the instrument so I could continue with my studies. I was thinking in terms of improving my violin so I could play better and was hoping for ways to match the quality I had ringing in my ears from listening to recordings. I thought I'd try to better myself first by getting a

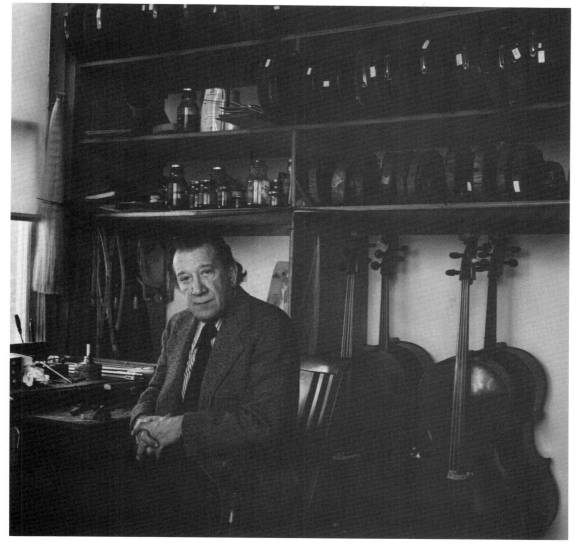

Frank Passa

good violin, but I had to do it my own way. In the course of doing that, I fell in love with violin making.

Violin makers have a problem that is special to the trade. It's a question of not forgetting that the violin is to be used for projection and beauty of sound, and not just for beauty of presentation. Our challenge is to make something that is beautiful from all four sides, which are always in view, but which also has a beautiful voice that can come out.

It's only in the last thirty-five or forty years that we've made some real progress in instrument making and started showing our teeth. Recently, just in the last five or six years, there's been a tremendous surge. For the first time in history, American instruments are being appreciated and are commanding good money. I think we're now on the par with the Europeans in many respects. Part of it's because, until not long ago, young men of the age who would be thinking about entering the field were all being drafted. They weren't getting a chance to use their talents, couldn't even consider taking the time to learn the skills. First they were serving their country, then they were serving their families.

Another reason why we've had a renaissance of craftsmanship is that over the years we've purchased from the Europeans so many fine examples of musical works of art. We had the opportunity to see them and reproduce them and use them as models. Especially pieces made by Stradivari.

He died at the age of ninety-three and produced 1,116 instruments in his lifetime. He is the one that perfected every detail and left nothing to be imagined after he finished. He was a great man, a giant. To some people that doesn't mean much. They think they're the giants. Some think they can improve on what he did; everyone tries. Someone puts a hole in a different place to see what happens, and nothing happens, so he plugs it up again. We've finished experimenting with the violin. For some people it's necessary to think they can outdo Stradivari. I myself think that in our business he's God.

When my three brothers and I were old enough to work, there was never any question about what we'd do. My father, William Campana, said, "If you're going to work for someone, you can work for me." I don't have any regrets. I learned the retinning trade from my father, and I'm almost sure he learned it himself in Switzerland. Most of the old arts were learned in Europe.

He opened up the shop in 1899 when he came to America. He was contented with the trade and always was conscious of quality. He taught us to be aware of it, too. In the early days there was more of a sense of community, and work was done in the old-world tradition. That old feeling isn't around much anymore.

When I started work in 1930, I remember we used to buy tin for twenty-five cents a pound. Now I pay ten dollars a pound. Tin comes in ninety-five or one hundred and five pound ingots, and I melt them down in the tin pot over a gas fire. It's the same way my father did it.

But the first stage of this work is cleaning the item you're retinning in a caustic soda solution that has to be heated to a certain temperature. Then it's rinsed in water, and put in a sulfuric acid bath overnight, and then in hydrochloric acid. After it's rinsed again, it's ready to go into the tin pot.

An apprentice starts by learning the cleaning points of the job. Every trade has its bylaws, and you abide by them. For example, one of the first things you have to learn is to keep your rubber gloves clean so you don't contaminate your acid tanks. Or, if you have grease on your gloves and it gets on the item you're retinning, the tin won't adhere where there's grease, and you end up with fingerprints all over it. It's a simple thing, keeping your gloves clean, but if you don't do it, you've got problems with the whole process.

The hardest part of the job is working at the tin pot. The tin is heated to a temperature of 550 to 600 degrees, and whatever it is you're putting in the tin pot weighs three times as much as normal when it's on the end of a pair of tongs. So if you're working with a commercial mixing bowl that

Herman Campana
retinner

weighs thirty pounds, you can figure out what it'll weigh when you're lifting it in and out of the tin pot.

After it's been tinned, it's rinsed again, and dried in a bin full of sawdust. If you used towels for drying, you'd need an interest in a laundry to keep yourself supplied. Besides, sawdust is a much better absorbent than towels.

In these old trades that are handed down from a grandfather or a father, you really know what work is. I'm hoping to retire at age sixty-eight, after forty-three years in the trade, and I have no one to leave the business to. Both my boys are doing well in other lines of work. One is a teamster and the other's a warehouseman. After so many years you like to see a place continue, but there just isn't much incentive for people to go into business for themselves in small service shops.

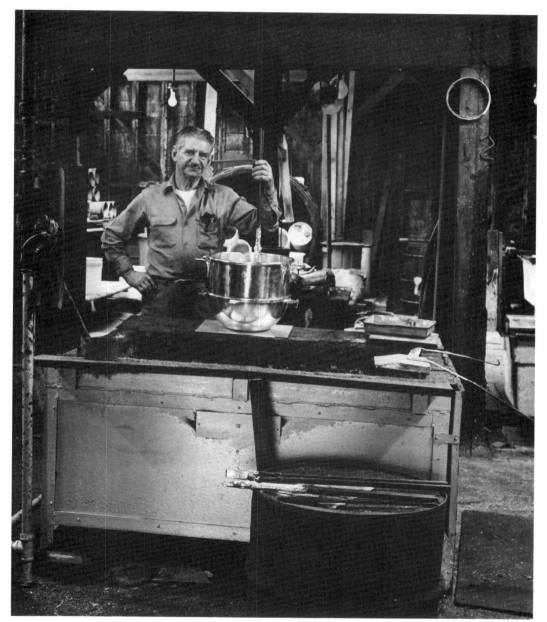

Herman Campana

Helen Weinschenk
shoemaker

On Thanksgiving Day of 1941, my husband and I were on the road to California from Chicago. It was a cold, windy day and our car broke down in one of those small towns. Nobody was around. Here was this big garage standing there, and we tooted our horn and got no response. Our carburetor was broken, and Art said we couldn't wait around. So he went into the garage, which was open, found what he needed, left a note telling what had happened along with the money, and fixed the car.

He could do his own work, because back in Chicago he had had his own very big garage. That was until the Crash came in '37, just the year we were married. He lost the garage and all the money. It was rough, but it wasn't too bad.

I've been very happy in California. Like my husband used to say, "This is God's country." I was from Chicago and he was born in Canada, but neither of us liked the ice and snow. We came out West to get away from all that. He'd talked about coming to California, and he'd talked about it and talked about it, and finally I said, "Either do something about it or quit talking about it." So, when at the age of twenty-five I quit working at my aunt's restaurant where I'd worked for twelve years, she wanted to know if I was gonna have a baby. I told her I just wanted a little time off to get ready because we were going to California. I was kinda looking forward to it, and for somebody who never went anywhere, never did anything, it was a big step.

The first place we went to was Yosemite. Art had a cousin there. When Pearl Harbor was bombed and war broke out, this cousin told him to head for San Francisco and get himself a job as a welder in the shipyards. So we came to San Francisco, and he did get himself a job in the shipyards.

In '44 was when I had my son; in '45 was when the war stopped, and the

16

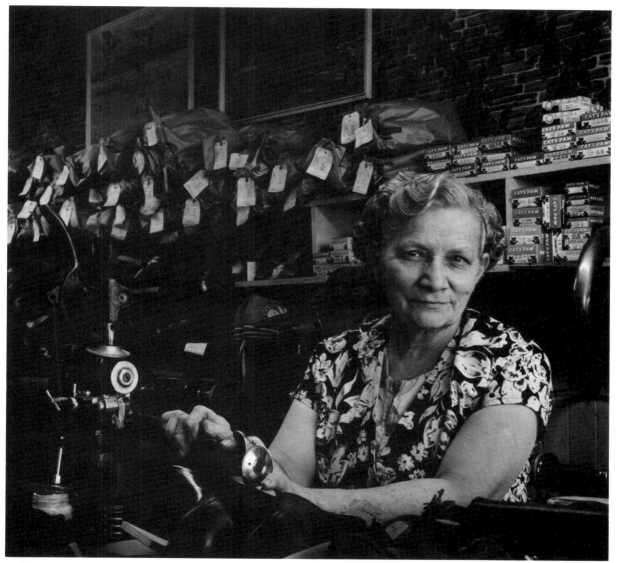

Helen Weinschenk

shipyards started slowing down. You had to think about finding some-thing else. Art and a friend looked around and they thought about getting into the shoe repair business, which Art knew from years back. Andy, my husband's friend, said, "You take this place and I'll buy myself a fishing boat." He was Danish and he loved the sea. So Andy bought himself a boat, and Art and I started in here. And we had this little three room apartment in the back. I've been here thirty years now.

After we got the shop, it took us, I would say, no longer than about two weeks to get established. We opened up on July 5, 1949. When we came here, there was a shoe repair shop in every block. Seven of 'em. When you're just getting into this line of business, it's tight. I still have the books. The old owners used to charge thirty-five cents for ladies' heels, and when we raised it to fifty cents, some of the ladies got so mad at us. We gradually raised prices as we had to, but you know, we weren't out to make a fortune.

The landlord was very, very good. We paid thirty-five dollars a month rent for the shop and the apartment. And then it went up to forty-nine, fifty, a little every couple of years. When he died, which was about four years ago, we were paying eighty-five dollars a month. We were here twenty-six years and never had a lease. Our landlord said, "I like you, you stay. I don't like you, out." I guess he must have liked us.

My husband got sick and passed away after being in the hospital about two and a half months. I'd kept the shop open during that time. After he died, I said, "Well, should I sell the business?" But when you're established here, and you've got your living here, where are you going to go? I was fifty-two at the time. My son told me he'd help me all he could if I wanted to stay open. So I thought I can do no worse than fall flat on my nose, and even if I did, I could still sell the place. My husband died on Easter Sunday. He was buried on Wednesday. I took care of my business at the city hall on Thursday. I opened up again on Friday, and I worked. People would come in and say, "Hey, where's your husband?" I'd cry, I'd turn around, I'd go back to work. That went on for two years afterwards. People would still ask about him. I'd tell 'em, I'd choke up, I'd turn around and go back to work.

Well, the way I did it could be related, like they say, to the time of year you're born. So I'm a goat: you know, stubborn. You just keep on working. I'm not going to sit and cry. It doesn't do one bit of good.

It got so busy I had a fellow come in to pick up shoes that needed soles, which he would do. We went on like that for years. Every once in a while he'd have a lost weekend, and there I'd be, having promised shoes to people, and oh, I'd be sick about it.

Anyway, with having him around most of the time to do the soles, I was taking in more and more work. I finally couldn't keep up with it. I was open five days a week, but I was actually working seven days a week and every evening. When young kids say they put in their nine-till-six and

they're bushed, they don't know what bushed is. But being alone, I could keep on. I'd come back here, grab a bite to eat, and it'd be back into the shop till eleven. When I got to be sixty-two, I thought I'd retire. But I still had an annuity to pay until sixty-five, and my social security would also be less. So I talked again to my son, and he wanted me to cut down my hours. I told him I couldn't cut down my hours, but that I'd lock the door two days a week and stay closed. But if a customer knocked on the window, I'd open the door. I just didn't like to have somebody knocking and nobody answering.

My suppliers always took good care of me. I used to butter them up, too. I'd often bring a cake with me when we'd go to buy. I had a husband who liked me to be right there with him. Came Monday, he'd get ready to ride out to the supplier. He'd say, "Honey, come along with me." I got to know quite a few people there, and we dealt with just one supplier all the years. Then when I was alone, came Monday morning, off I'd go on the bus to the supply house, sometimes with two cakes. There I'd be, juggling cake boxes on the bus. Then when I'd show up without one, they'd say, "What, no cake?" They missed me after I quit. Every once in a while now I'll chase down there for something, but if I go, I have to take a cake.

I always brought cakes to the Noe Valley Merchants' meetings, too. I've gotten some lovely gifts from them. Inscribed plaques, a cake server. They tried to get me to go up as vice-president, president. But I said, "Please, no." I've never been a club woman. I have no idea of how you run an organization. When I retired they gave me a party, and I got a wrist watch, a chime clock, a money tree. When I walk up the street, I see all my friends. I think I'd be lost if I left.

I've been running the shop myself for thirteen years; the fifteen years together with Dad makes it twenty-eight. The satisfaction of being able to do it stands out. But I couldn't have done it without my son's help. Not having to go on welfare counts, too.

I've always been extrememly fortunate with my health. You don't look for aches and pains. Once I caught this finger in a machine and sliced off a piece. So you wash your hands, put a couple of band-aids on real tight, and go back to work. I dropped one of the iron shoe lasts on my toe, and I've got the ugliest-looking toenail you ever saw, but I never went to the doctor. I'm not a doctor girl. But I did have one come in when I took out my annuity insurance policy, because they required it. He took my medical history and blood pressure, and I said, "Well, how is it?" He said, "I'm twenty years younger than you, and I wish my blood pressure was as good as yours."

I never expected much out of life; I still don't; I still haven't got much. As long as I've got my good health. That's the main thing. It doesn't take much for me to be satisfied.

Andrew Fisher
sailmaker

Andreas Fisher was my grandfather's name, and when he was seventeen years old, he left Denmark with nothing much more than a sea bag and came around the Horn in a sailing vessel. He's there in the lower picture. He'd learned the sailmaking trade in the little town he came from, and when he arrived in San Francisco in 1871, he started working as a sailmaker. In 1876 he went into business with Mr. Simpson.

Mr. Simpson ran the office, and my grandfather made the sails. Mr. Simpson disappeared sometime in the early 1890s—no one knows what happened to him. He might even have been shanghaied.

My grandfather worked himself to death at an early age. He lived fifty-three years. My father, who's in the middle picture, lived sixty-three years, and I'm seventy-one and a half already. Nowadays the sailmaking business is pretty lightweight work. But in those days it wasn't. We've got pictures showing the old crew: big, hefty guys with beards and moustaches. They'd be sewing heavy canvas all day long. You had to be pretty strong to do that. When they'd sew a double seam, they'd have one man on one bench and another on the bench behind him. The forward man would put in the first row of stitches, and the man behind him would put in the second row. They always put the fast guy in the front so he'd make the guy behind him keep up. When they got the sail finished, they'd roll it up, and half a dozen men would put it over their shoulders and carry it down to the waterfront.

The modern sailmaker has it a lot easier. He subscribes to a computer service, and when he gets an order, he gets in touch with the computer company. They give him all the dimensions, so he doesn't even have to lay the sail out on his deck. He just cuts it according to the computer program. That way they can use inexperienced people, and anybody who can run a sewing machine can sew up the sails.

We still draw the layout with chalk on the deck and cut the pieces of

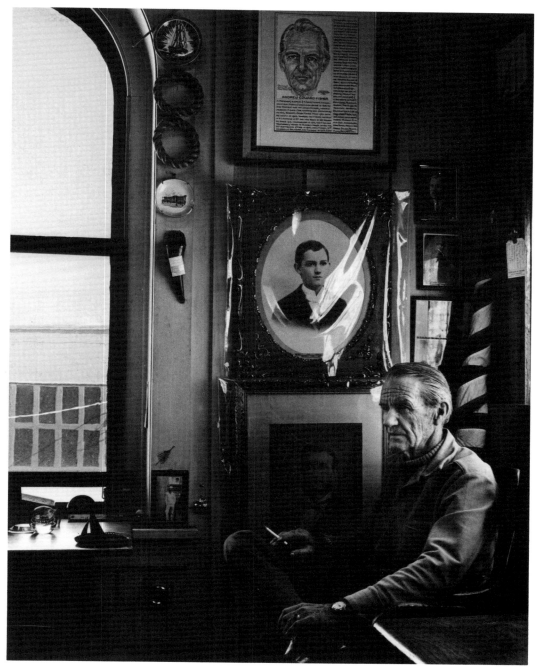

Andrew Fisher

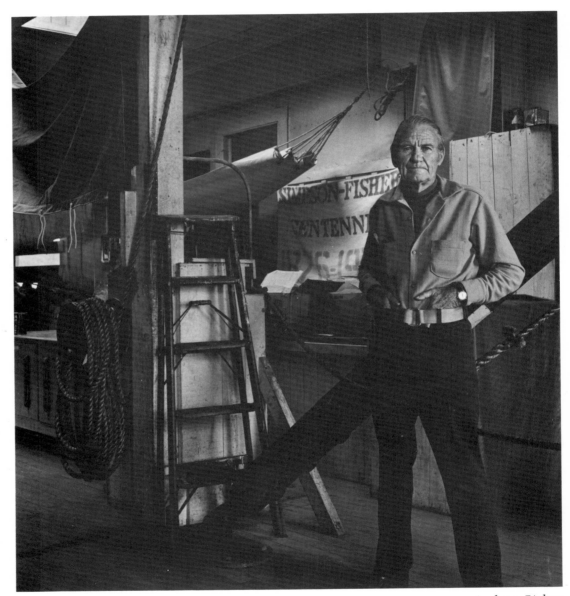

Andrew Fisher

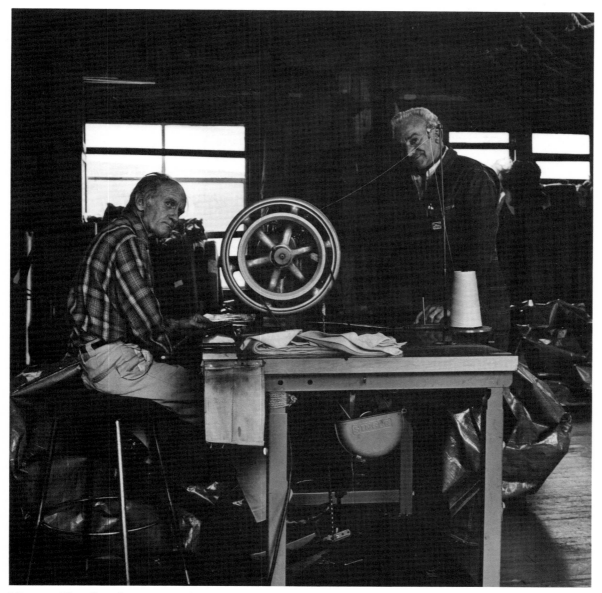

Warren Olwell and Mario Luchessi, sailmakers at Simpson and Fisher Company

cloth right there, and then take them up and sew them. It's the same way they did it in my grandfather's time.

Some of the sewing machines we're using were put in in 1917, and they're still running. In fact, they run better than the new ones. When the old machines were put in, they told my father to run them at 400 rpms, but he ran them at 600 rpms to get the jobs out faster, and Singer told him they'd never last. Well, they're still running, and the ones that aren't in use are out of commission only because I can't get parts for them.

After my father graduated from school, where he studied business, he learned the sailmaking trade in the shop. He then became president of the corporation; the business was incorporated in 1903. My father ran the office, but when they were busy, he'd go out and work on the bench. He did both, and I don't know which he liked best, but he did the job.

There were times when things were pretty rough, like during the 1932 Depression. He was offered a thousand dollars for the business, and he wanted two thousand, but nobody had two thousand.

Now people don't have to work so hard, and they live longer and they get more money. So I don't know what's better. In the old days there wasn't any welfare or unemployment. If a guy didn't work, he didn't eat. That made him more anxious to do a better job.

My father used to take me aboard some of the old sailing ships when he had to make measurements. If they didn't have the sail plans for a vessel, they had to go aboard and measure it. They'd do the measurements and they'd make the plans and keep them on file for next time. Once they had the plans on file, if a ship needed a sail and would be in port at a certain date, the captain would notify the shop, and when they arrived it would be ready. To notify the shop, they used the old cables, which they'd send from whatever port they were in.

Sailmakers in the old days got pretty good wages. For example, in 1903 they were making five dollars a day and one dollar an hour overtime. Sailmakers did float, though, just like sailors. Some of them were sailors and sailmakers. The sailing vessels always carried a sailmaker on board to make repairs.

There are none of the old guard left. There was one fella named Harry Lawry who used to sew the sails by hand. He worked here from 1913 till 1971. Three years after he retired, he passed away. He was a great personality: the kind of guy who, if he knew you needed money, why he'd give it to you, not lend it to you. He used to drag me around the deck on the flap end of a roll of canvas, giving me a ride while they were unrolling it.

One of the things men would do back in the old days was get together in a group and form a syndicate and buy a plank, it's called. A plank cost one thousand dollars. You got one plank for one thousand, two for two

thousand. When they got enough money, they had a ship built, and they'd hire a captain to be business manager and to sail the ship. He'd sail it and pick up and discharge cargo and keep a record of his expenses. Things like food, supplies, wharfage fees, a case of whiskey for some guy named John Jones who they wanted cargo from, would show up on the report. At the end of the year he'd give the accounting. If there was any money made, it would be split up into shares according to the number of planks you had. Of course there wasn't any income tax. But that wasn't a very profitable business because one of those ships sank the first year it was sailing, and the other one sailed for three years and then it burned. And there wasn't any insurance either.

My father used to bring me over here, but he couldn't get me interested in learning the trade. But I was exposed to the sea and the sea business all my life.

I retired from the scientific instrument business in 1967, and the two people who were running the shop both died within a year. I was retired for a year, and then I came and took the place over. I'd been playing a lot of golf, and once one of my friends asked me what I'd do if I couldn't play golf. I said, "I'd be doing something useful." Since I never did learn the trade, having liked studying chemistry in college a little better than sailmaking, I really came over to the shop to run the business end of it and keep the place going. I don't regret taking over the business because it's been very interesting. I wouldn't have missed it for anything now, and I wouldn't have taken it fifty years ago.

One of my favorite mementos is that homeward bound pennant. It has thirteen stars on it and it's thirteen feet long. My grandfather made it. The sailing vessels used to fly those from the masts when they were on their way to their home ports. Of course they never use them anymore. That's something that's been lost.

Virgil Antolini
ironsmith

When you're in a small place like this your blessings come slowly. Everything we have we own now, and we're pretty well off in the sense that there's nothing hanging over us. It's a result of being independent and paying your bills and having a good reputation in the business itself.

Because you work for yourself doesn't mean you have it easier. It's not easier. It's harder. You put in a lot of time, but it's worthwhile because you're your own boss. You can put quite a value on that if you stop and think.

Sometimes when you come back on a Monday, it's like a new page. Each of the jobs is different. You know, you have these big corporations, and the work we do is like a hot potato in their hands. You can't mass produce it. It has to be done individually and it's made special to order. Sometimes you look forward to getting up and getting over to the shop. It's not like it's something clean—just look at these hands—but it's a satisfying type of work.

I've been doing iron work all my life. First I worked for one of those big iron concerns for twenty years. I started with the original bosses. Then I went into the service, and after I got out, they were going to sell the business. In the meantime I found this Mr. Costa and he said, "If you're not too anxious about the money part, there's a lot of satisfaction." I came in with him; it worked out. I've been here thirty years, right up through the time he passed away a few years ago. Now I own the business and the building.

The original owner was a wagon maker, and when I bought the building from his son, he said, "I really want someone to have the place who is going to use it as an artisan shop." I still have the barns out back where they would keep the horses overnight while the wagons were being fixed.

I'm sixty-seven, and next year I'm gonna try it with just coming in a couple of days a week. I've got some hobbies I've put off, and I want to be

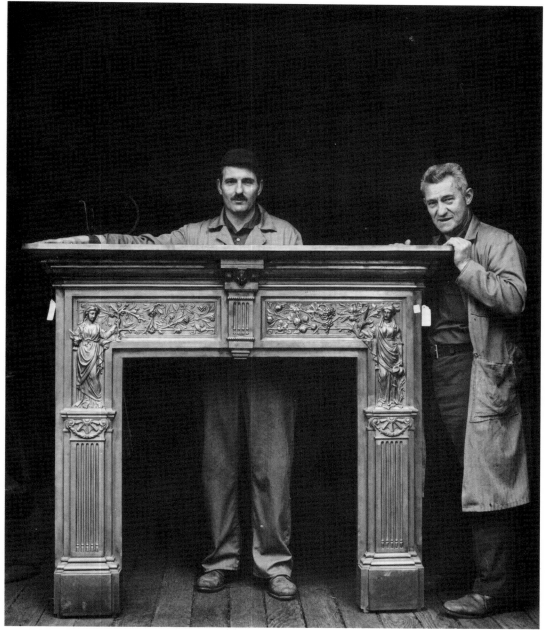

Bob Guglielmi, Virgil Antolini

able to enjoy them. But the shop will always be here, especially because we own the building.

I've always been an active person; I can't sit down at a desk job. So I'll probably do the fine part of the iron work. Right now we have a lot of commercial work, but there's so much of that fine stuff that I haven't been able to do. It takes time. You know, in a partnership like this every job has to pay off, a little bit anyway. But when you do things because you like, you love, you desire to do them, you're not too concerned about how much you make an hour. We were approached a few years ago to restore a Cellini gate. It was made way back in the 1500s. It had been brought in from Europe and was put in a club, and the building burned down. But of course an iron gate wouldn't burn. They were afraid someone was gonna steal it, so they hooked a chain on it and pulled it off the wall with a bulldozer. Oh, they contorted it, honest to goodness. If you see that gate, it is, in itself, a piece of art, and it would take at least a year and a half or two to restore it. You look back to the 1500s and you still have this gate, and as you go about trying to straighten it, you see the way it was assembled. Everything was filed and fitted, and everything should still fit. The time they took to make something in that category was fantastic. But they didn't care about that then. To take on a thing like that today, you got to have all the time and all the desire to work on it.

I come from Northern Italy, and they still have it driven into them, the young generation, that you have to learn something practical. You never forget that. You can do whatever your bit is, but you have that one trade. It's like money in the bank. When we were young, even after school they used to send us over to a little hole-in-the-wall they called a shop, where they were fixing bicycles or something like that. Sometimes our folks had to pay the people so we could go over there. The owner would say, "How much you gonna pay me? You make my men lose time, having that kid around." Now when someone comes in, the first thing he wants to know is how much you gonna pay him, before he even knows anything about the trade. That's today's world—you have no alternative. You gotta follow it.

We don't have many guys coming in to learn the trade. The desire is not there.

It was by luck, really, that I became a tool and die maker. I was in the first class at Oakland Technical High School, and there was a long hallway with shops on both sides of it. Blacksmith, woodworking, machine shops. I could have walked into a carpentry shop and been a carpenter. But I walked into the first room on the left, and it was a machine shop. My other two brothers went down the hall, and one became a pattern maker and the other a draftsman.

I served four years after that as an apprentice at Halls Scott. They paid you fifty cents a day when you were starting out. Then each year you got more and more, until you were making twenty-five cents an hour. Then you became a journeyman and got regular man's wages. I worked there fourteen years until I went into business for myself. During that time, I'd take my paycheck home and give it to my father. He'd put part of it in the bank and give me part for spending money. I managed to save up four thousand dollars that way. That was the money I used to buy into my business.

The guy who was working next to me at Halls Scott used to say, "How about going into business together?" I'd say, "Sure," and not think about it much. He finally went into business with another fella, but they couldn't get along; so he came back to me and asked if I'd like to buy the other guy out. So we started working together in Steve's garage. That was in 1929, and all in that year I had quit my regular job, gotten married and started a new business.

In 1930 we had the building built that we're still in today. It was cheap to build, because in those days everyone worked just to keep working. It cost us four thousand dollars to build a brick building. We had a few basic tools, and we gradually bought more. Times were tough, and we'd go to auctions and get 'em second hand and fix 'em up. At the auction sales, if you were lucky you'd get a tool that was in almost perfect condition from a guy who went broke, and you'd buy it practically for nothing.

It helps a lot to have a nice partner. In forty-five years together, we never fought and I never came home mad at him. We understood each

Louis Ravizza
tool and die maker

29

other. He wanted the shop to have a name that said we were artists at our trade. That's how we came up with the name Art Tool and Die.

We had a group called the Mother's Club. I never did know why they called it that. We met once a month at someone's shop and showed the work we were doing, and then went out to dinner. Once a year we'd have a Christmas party, and the wives would come, too. It's still meeting, but some big shops and salesmen came in, and it kinda spoiled it.

It started in the thirties, and how it started was because during the Depression a customer would go around to the shops and try to get the lowest bid. Sometimes he'd say someone gave him a bid of a dollar fifty when it was really two dollars. So we started to communicate with each other and let it be known what the real bids were, and who was trying to phoney them. We were trying to protect each other. Also we'd mention poor payers and tell the other fellows to be careful of the guys who didn't pay. In those days there were a lot of poor payers. If a fella had a good idea, he'd do about anything to get it made so he could make money. You saw a lot of chiseling and cheating. Later on the club became more of a social thing, but for a while we were our own Better Business Bureau.

I've been doing tool and die work for sixty-three years. I'll never retire. My work is my hobby.

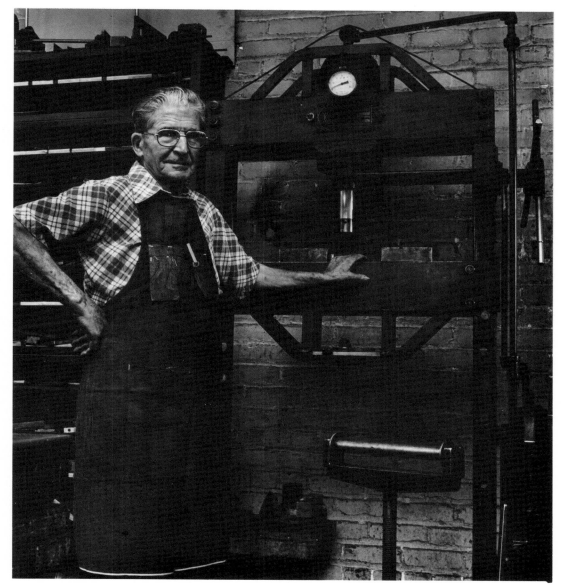

Louis Ravizza

31

Harvey Egbert
silversmith

A silver polisher for thirty years, Harvey Egbert retired at age seventy and is living in Reno, Nevada.

Harvey Egbert

Roy Haver
marble worker

At the time I became a marble man, I started in a shop that had 120 men. It was one of the biggest shops west of the Mississippi, and my father was the straw boss. He was thirty years in the trade, and I was pretty close to him and saw that he was happy. It seemed natural for me to take up the trade, too.

I was seventeen when I began. I did four apprenticeships and have been in the trade for twenty-seven years. I've seen it change a lot. San Francisco used to have seven big marble shops. Now there are two small ones. The big places used to have several guys who were carvers doing statues, and they're not around anymore. There's not enough call for statues now.

The imports really killed us. Imitations, too. A lot of the imitation marble goes into tables and sinks, and people will settle for it because it's cheaper. Because of the imports and imitations, we've had a slack period for fifteen or twenty years, and a lot of good marble men left the trade. Now things are picking up again, and if a good man came in we could probably find room for him.

I always liked the work and still do. I wouldn't have changed anything about that for myself. I've got two boys who I might have wanted to go into the trade years ago, but not anymore. In fact, they've shown interest and I've discouraged them. Now they're auto mechanics, and I think that's a better trade, only because you know it can keep going. Marble is one of the first things to slack off when things get tough. A person will give up a marble floor before he'll give up his car.

34

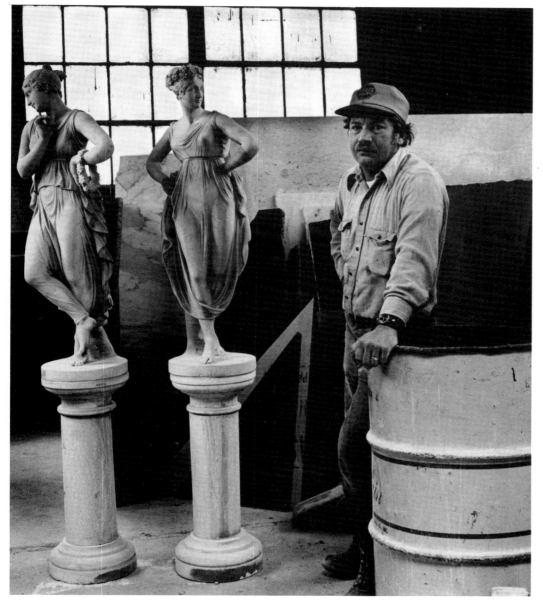

Roy Haver

John Lukas
stained glass artist

One day, back when I was in art school in Los Angeles, a professor and I were walking down the street, and we passed a stained-glass studio. We looked in the window and it was a dusty-looking place. He said, "Hey, maybe you could get a job here since you're interested in mural painting." So that's how I got the idea and it worked out pretty well, because stained glass was kinda related to mural painting in its scale, and being sort of architectural.

I'd just finished school and needed a job, and I tried all the stained-glass shops in L.A. Nothing doing. So I came up to San Francisco, nothing doing; went back down there, nothing doing; came back up here, and finally somebody got a big job and hired me to work on it. That was in about 1940. There wasn't much demand for art then. For one thing, it was after the Depression and it was hard to get a job. There weren't too many artists and most of them were on the WPA. After the war it picked up, and we were busy doing church windows.

If you want to do the designing in this business, it makes quite a difference to have a fine arts background. If you can't draw or design, about all you can do is make little squares or diamonds. Of course you could make up other people's designs, but from my point of view there wouldn't be any sense to that. The kicks are in making your own designs. My son Nick decided to go to art school, too, and he's been working with me for about ten years.

When we do a window, the subject matter is sometimes chosen by a committee, but lots of times we can make suggestions. The interesting side of this trade is that with each project you have new problems to solve. Either technical or design problems.

But when you're beginning it's a lot of hard work, and you're not too concerned about thrills from big jobs. You're kinda more scared, and you're hoping it comes out all right. You spend a lot of effort and

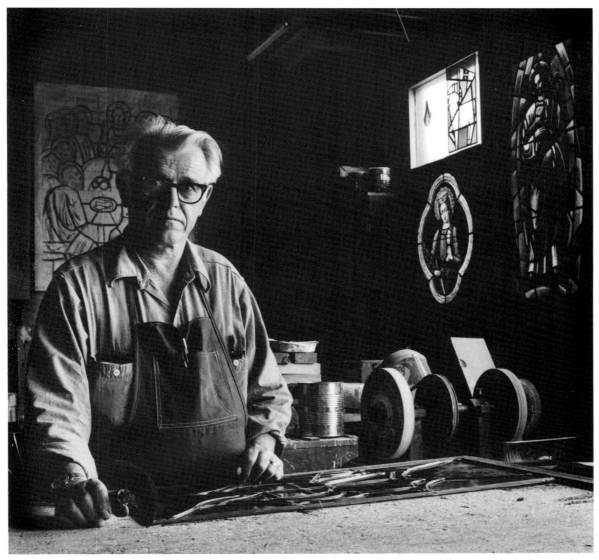

John Lukas

perspiration. Then as time goes by and you're more at ease, you're more thrilled by jobs, and you can get enthusiastic about problems and challenges.

You get your share of surprises, too, sometimes on installation and especially on restoration. Often the lead on the windows is seventy or eighty years old, and it's gotten a little tired. If it's oxidized and rotted and you go to take the window apart, sometimes it falls apart. That doesn't happen too often as you get older and more experienced, because you take them apart quite cautiously. I remember the first time it happened to me twenty-five years ago. It was a noisy shock. Some of the pieces broke, but not too many, because you're all hands then. You're really flying around, catching things.

In the European cathedrals, they have to take the windows out every fifty to one hundred years or so, and they have eight hundred years of experience with it. Now as those countries are being polluted, the buildings are being eaten up, and the windows are affected, too. The whole deterioration process is going faster.

The Victorian thing is very popular now. It's sad that we have to go backwards. Many of the churches here in the U.S. are Gothic cathedrals, and they went back hundreds of years to be impressive instead of making a new idea. We're doing the same thing now. We're making little Victorian things instead of making something of our time. There are just a few who will do work of our time, like in the Renaissance when there were a handful of great men. Each century only brings a few. The Renaissance was an environment in which the outstanding people could develop. Maybe out of all this, some people will also emerge as individuals who will say what our time is. It won't be what *Life* magazine says it is. It'll be whatever John Smith wants to do.

For myself, I like working with religious themes. There's a lot of material to draw on, and you learn a lot. I think I consider myself a religious person. I grew up in a Greek Orthodox atmosphere. One of my uncles was a priest, and I used to serve at the altar. Grandma talked religion a lot and so did my mother. You never really think much about it since it was just a part of life, but my childhood had a religious feeling to it. I guess that's why I can spend a lot of hours here in my shop.

The way that I came into the plating trade was by chance. Back in 1955 I had just gotten out of the Navy and I needed a job. I wandered over by a plating shop. I'd never seen plating and didn't even know what it was. It was lucky for me they were hiring.

I started out as a helper, making a dollar sixty-nine an hour. My job was cleaning metal for the journeymen, and I did that for three straight years. I finally got journeyman status myself after I did another three years of apprenticeship.

It's a trade that's been very good to me. A lucky chance turned out to be a twenty-five-year career. At the time, I never would have thought I'd stick with anything for twenty-five years. I used to like to wander.

As you get older, it gets more satisfying because you've already grasped the trade. You're a journeyman and don't have to worry about getting laid off, and you're getting good pay. You've developed your skill and you know what you're doing. It's satisfying to me because when I go home at night, I know I did my job well.

Raymond Rio
chrome plater

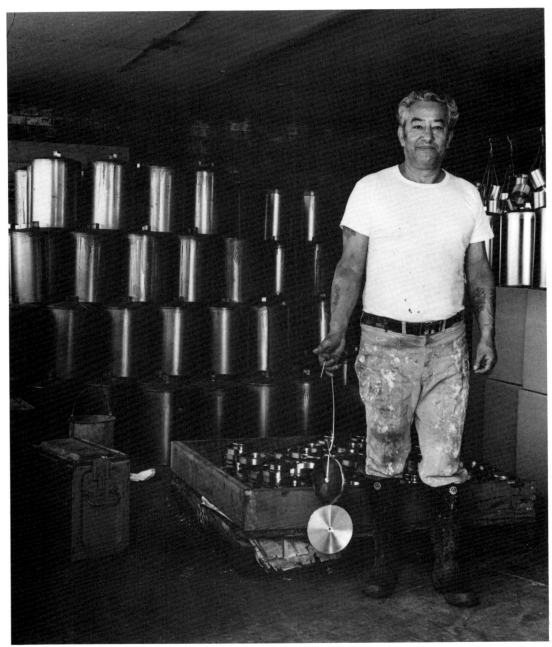

Raymond Rio

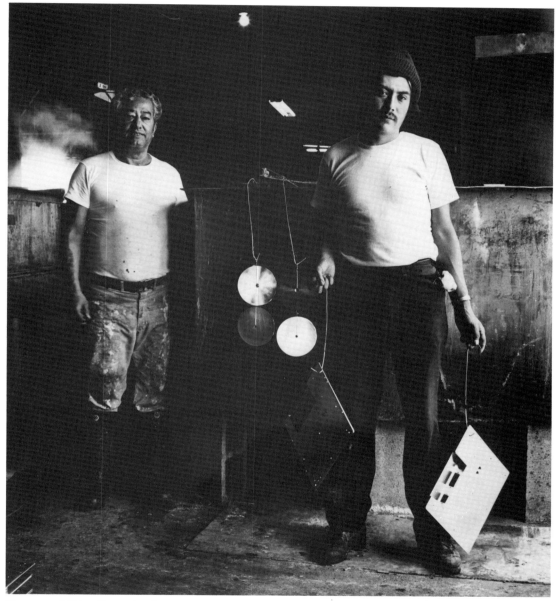

Raymond Rio, Rosario Rameriz

41

Lawrence Fambrini
brass metalsmith

I'm the old school. I'm not a college man or a mechanical man. When I make a circle, I just get a piece of string and map it out. I don't like using mechanical stuff like compasses and dividers. The satisfaction for me is to take raw materials and make them into a brass chandelier people appreciate. I love the work. I love to create.

Sometimes when I make a lamp or chandelier, I cut all the pieces by eye. Sometimes you come out good; sometimes you come out a little crooked. Nature is never perfect; same for things made by hand. You can't find another one like it, because it's from the imagination. I like to go downstairs to my storeroom and pick out parts and put them together. You have a lamp that's all handmade, and you like to add a little something here or there to give it more feeling.

It's nice to work in a small shop and do your own designs. But it's hard working for some clients. Some come in and tell you how to do it. Our old designer Mr. Roller used to say, "Dearie, do it yourself."

It's really a shame the old-timers like him are either quitting or fading away. Today people are all for the money. They work for the wages, get the job done, and go home. They don't have any feeling for the work. I tell people, if you don't love your work, then it's work. Mr. Roller was the same way. He had a lot of opportunities to be great, but he didn't want that. He wanted to stay where he was.

Mr. Roller was a special breed. He'd come back here in the office and stay all day long. He didn't bother about going outside. If a customer wanted to talk to him, he'd come out. He started to work for the original company, Thomas Day, in 1929 when he was seventeen years old and quit when he was ninety-five. The same job. His whole life was right here. He designed the old street lamps on Market Street, the big sunburst light in the Opera House, and the chandeliers for the Palace Hotel. They were all produced right here in the shop. Mr. Roller never knew anything mechanical. He couldn't tell a wood screw from a machine screw. But he

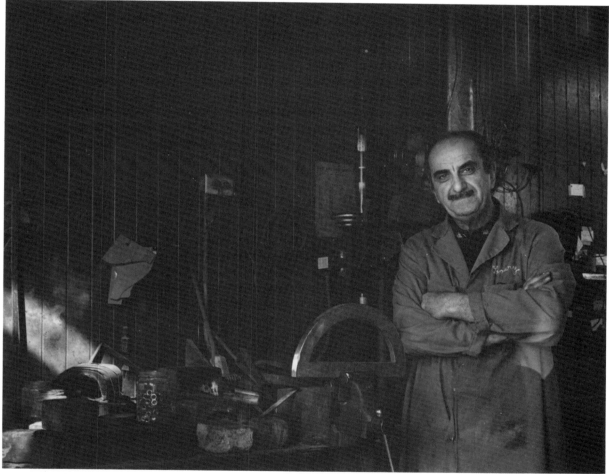

Larry Fambrini

knew design. You could walk in here and say, "Mr. Roller, I want a design from Pompeii," and he knew it. I wish he was here now.

Right after high school I worked for my future father-in-law, Ben Guglielmo. I trained with him until I went into the Navy. After the war I returned to the same shop and I have been making chandeliers all my life. Later I worked for the Phoenix Day Company, which was owned by Ben's brother, Joe Guglielmo.

In the old days, the shops of one kind were on the same street. The commercial shops, the clothing stores, the artisan shops were together. The metal-working shops ran for about seven blocks up Mission Street. It was like that up until World War II, and then the city started to spread out.

In the old shop we used to have a forge and men who worked in brass, in iron, and some who did the castings. But the old-timers are going. We had one who just retired early at age sixty-three. He worked in the trade about forty-five years. I said, "Frank, since you didn't like it, why didn't you ever quit?" He said, "I was raised to start a job and finish it."

In the old days you never moved. You also worked a lot harder slamming that iron with a sledge hammer.

I like to work freely, not have pressure. One of the best things about working in a craft you really like is that you can picture yourself still doing it when you're eighty-five or ninety.

There are three families that practically own Whitman County, Washington, where I was born and raised. But they haven't got our ranch. It's still in the family. I told my niece if she ever sells to one of those big landowners I'll shoot her. We're one of the last small farms up there today.

There were twelve kids in our family, and my older brother and I saw there was no future for us on the ranch, so we came down here in 1928. It was the Depression, and my first job was shoveling manure twelve hours a night at the stockyard in South San Francisco. I started in the evening, and in those days it was colder than it is now, and foggy. One night it was raining something terrible, and I was out in this cockeyed yard. Came midnight, I had my sandwich and went down to the furnace room and went to sleep. They didn't find me till six the next morning, and they fired me. I had practically no money.

I went across the street where I saw Swift and Company. I thought, come Hell or high water, I'm gonna get a job there. I went over there sometimes twice a day, and the fella that finally hired me after about two weeks said, "By God, I'm gonna give you a job. You're driving me nuts." His name was Roy Buer and I still see the man once in a while. He got me started in my first business, the meat business. I ended up getting my own butcher shop and ran it for thirty-four years.

As far as I'm concerned, I never really was out of the saddle and harness business, because I've been collecting the stuff for thirty-five years. I've always enjoyed being around horses, too. On the ranch we had from thirty to forty head of work horses and three or four saddle horses. When I was about fifteen, I drove thirty-three head of them on an eighteen-foot combine. Now I have a three-box stall at home, but I don't keep my horses there. They're a mile away on two acres, and my hobby has grown so big that I don't have room for them. I have over twelve hundred bits, and it's all old stuff. A couple of pieces are over three thousand years old.

My partner, Dale, and his father used to drive the six-horse Clydesdale hitch for Wilson Meat Company. Before that he used to ride broncs and

Paul Busch
*saddle and
harness maker*

bulls and all that sort of stuff. He learned a lot of this repair work when he was with the meat company. Even the best horses tear up harnesses pretty good. They used to drive the horses around to the small grocers, and one evening they were in our neighborhood. I said to my wife, "I'd like to go down and take a look at the horses," and she said, "I'd like to go with you." That's how I happened to meet Dale.

The two of us got into this business because I'd known old man Starr, who started the shop, for thirty-five years. In 1967 he wanted to sell me this place. He said, "Come on Busch, why don't you buy this? I'd like to get out, and I'll make you a good deal." Well, I still had one business and didn't think I needed another. He died at age eighty-three, and about that time Dale had stopped driving the truck for the meat company, and I asked him if he'd like to buy a saddle shop. He wasn't so sure, but we looked the place over and his eyes kinda opened up a little bit, and we decided to make a bid on it. There for a while I wasn't doing anything except playing with my hobby at home. It felt good to start something again, and I'm the kind of guy who was brought up to work.

When I was a kid, I milked a half dozen cows each morning before I went to school. I'd get up at four o'clock, feed the calves and do my chores, and then ride the old horse five miles to school. One winter, believe it or not, my brother and I never missed a day of school.

When farmers got rid of their horses and changed to tractors and caterpillars, a lot of them got rid of their old harnesses, too. My brother-in-law had beautiful old stuff, and one day he took it all out in the yard and poured gasoline over it and set it on fire. It makes me sick to think about it. He said, "What the Hell am I gonna do with it? It just sits around and gathers dust."

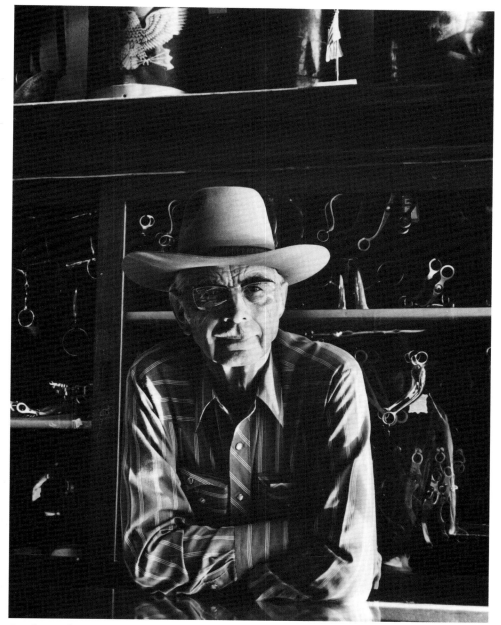

Paul Busch

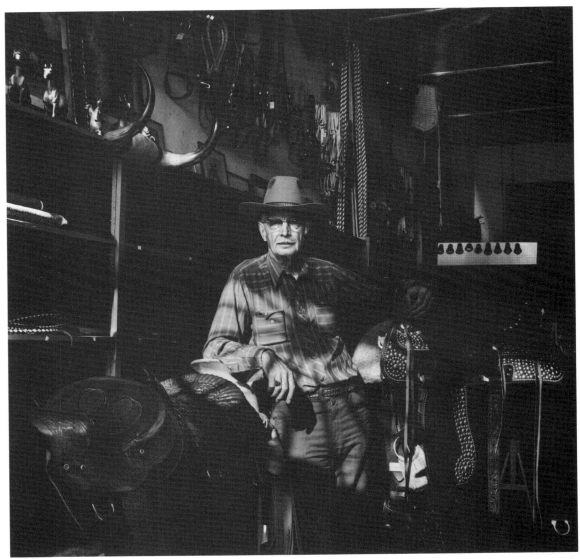

Paul Busch

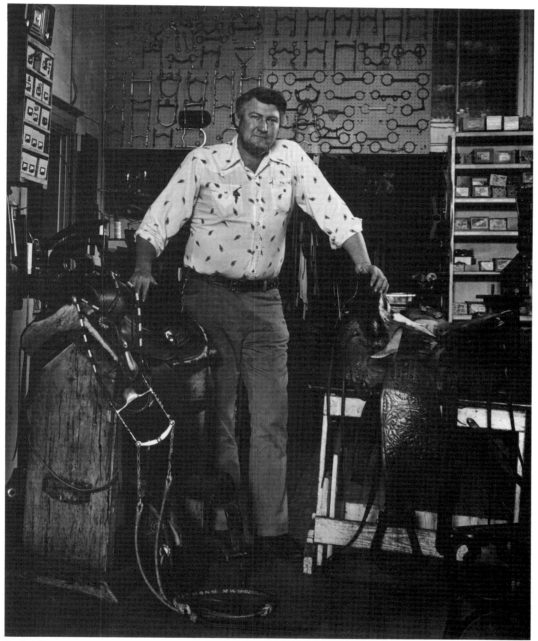

Dale Yearian, partner, Starr Saddle Shop

Pat Morello
wireworker

Pat Morello moved the family wireworks to a small town in Oregon in 1978. He subsequently sold the business for health reasons.

Pat Morello

Valentina
seamstress

I was taught how to sew by the nuns in a convent in Northern Italy. That's where I spent my teen-age years. There was always a lot of fine needlework to be done. We made altar cloths and embroidered religious symbols on the priests' vestments.

When I became nineteen, I wrote to my mother, who had left Italy and was living in California, and asked her for permission to take my vows so I could become a nun. She wrote back and said, "No, I want a different life for you. You come to California." I was very disappointed, but I had no choice.

One of the first people I met after I arrived in San Francisco was a sculptor. He said, "Valentina, you have the most beautiful hands and feet I have ever seen. I want you to sit for me, so I can put them on a statue of a saint that I am making for a church in North Beach."

I thought to myself, I think I am going to like this place.

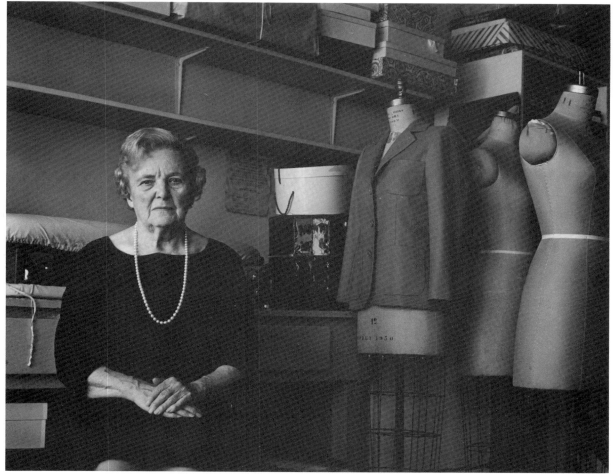

Valentina

Duke Cataluna
blacksmith

I was fourteen when I started blacksmith work back in the Hawaiian Islands. I went in as a helper in a shop on a plantation. You just go in there, be a helper to the blacksmith, and when you become old enough, maybe somebody quits and you take his place. After about eight or nine years, the Japanese man I was workin' for retired, and I took his spot.

Then in 1939, I more or less could tell the war was gonna come. Things were licking up a little bit. There were a lot of Japanese around, and you could kinda hear something about it. And they were building airfields. I knew I would get drafted, because I was twenty-nine, so I quit my job and got one with the U.S. Engineers. I went in as a welder because they didn't have no blacksmiths.

When I worked for the plantation, I had forty dollars a month and a free home. The Army Engineers gave me a dollar twenty-five an hour. One hundred twenty-four dollars a week there, and I had only forty dollars a month before. I worked there awhile and the war broke out. The wife went to work in the Army laundry. I was the last one to get laid off after the war ended. That was in 1947.

After the war I told my wife and daughter that at last we were gonna take a vacation on the Mainland. I didn't go back no more to Hawaii. I got a job here in Oakland as a blacksmith for three years, and then they had a big lay-off. I looked around and found a job at a small shop called Merritt Blacksmith. I worked for Mr. Merritt for about ten years, and then he retired and I bought his place. When I came here, I never planned to stay, but I got the right job and everybody was good to me.

I was very happy when I got my own business. I used to go down sometimes at three o'clock in the morning. Me and my son worked together every day for eight years, and we built up the place. Once we worked one week without sleeping to build the anchor bolts for the control tower at the Oakland airport. They went hundreds of feet into the ground.

After a while my son said, "Dad, I don't want to work in the shop anymore. I want to go into trucking." So I bought him a truck and paid

54

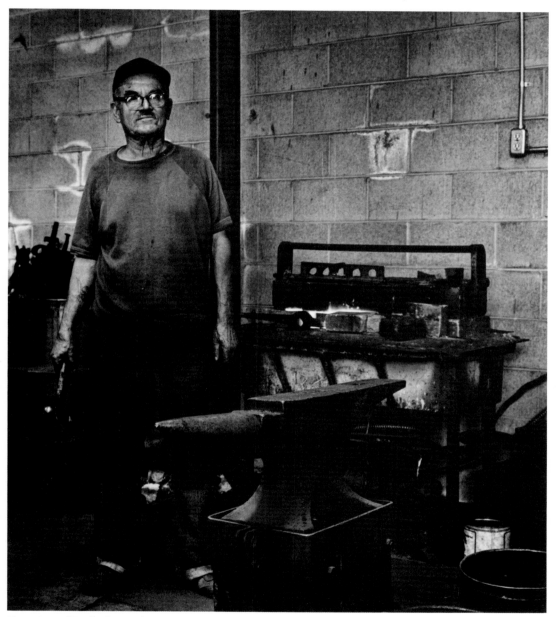

Domingo "Duke" Cataluna

thirty thousand dollars for it. He kept workin' in the shop and got himself a driver. He kept workin' and workin' and he made good. I bought another one, and then another one, and now he's got twenty-eight of 'em. Cataluna Trucking he calls the business.

I decided to sell my business to a young guy who had been driving a truck for my son. I stayed on and worked for him. After quite a while, he sold the old place and bought a new one, and I kept on workin' with him. I'm the oldest-timer here.

I retired for a year, but it's pretty hard to find a blacksmith now, and he begged me to come back. Now I'm a part-time worker. I got the smallest pay, but I don't care because I got enough money. As long as I'm workin' here as a blacksmith I'm happy.

Blacksmith trade is dying out. You have to do the work with your hands, and it takes years to learn it. To learn to make a hammer takes about six years.

Foundries make hammers, too. They make anything you want. But they won't make just one hammer. It costs too much to make the mold for only one. Theirs are beautiful and they all come out perfect, but you can't beat the one made by hand. The foundries can make tools, but they can't sharpen them. I sharpen their tools. For that they have to hire a blacksmith.

I think they're trying to start a school to teach blacksmiths. It takes about ten years to learn to be a first-class blacksmith, and these young boys don't want to take up the job. They think it's too hard. They want to learn right now and make a lot of money. They have to do something about it if they want to keep some blacksmiths.

I been in this work so damn long, I really love it. I don't want no other job. All my life I've been a blacksmith.

Our shop began with Grampa. He started back in 1904 working in the field as an artist drawing art and leaded windows. He didn't like the way the fellows cut out his designs, so he got mad and decided to learn how to cut his own glass on his lunch hour. At the time, he was working for a master craftsman named Bill Dombrink, and then in 1922 he started his own business on Twelfth Street in Oakland. He was a fine craftsman and an artist, and he didn't take any guff from anybody. He learned the old, hard way, the English way. Morton Bendell was his name.

Dad came in right after high school, and he bought Grampa out in the early fifties. I came here in 1960 and started out at the very bottom as an apprentice. Four years later I became a journeyman, and in 1973 I took over fifty percent of the business. Although Dad is more or less retiring out, he still does the majority of the fancy cut work, and I run the business end of it.

Back in the early days my grandmother worked in the office for many years, and Mother also worked with Dad for a long time. My sister worked here, too, for several years, and when she moved away, my wife came in.

Most of our men have been trained in sort of a hand-me-down process that began with a man Grampa trained named Paul Stallone. Paul then trained a couple of guys, who each trained others.

We still do our silvering the old way, using a two-part liquid silver nitrate solution that we mix ourselves. I think we're the only people in Northern California who still do it, and it's the only process for restoring fancy, beveled antique mirrors. Electroplating is what's mostly done today, and that's fine as long as everything is standardized and factory produced.

From time to time we get jobs restoring things like antique glass doors to their original form. Projects like that remind me that the old way still works, and that some things can't be done by machines, only by people.

There's something a person has to have in him to make him want to be an artist or fine craftsman, and I think there are fewer of those people

Tom Bendell
glass beveler

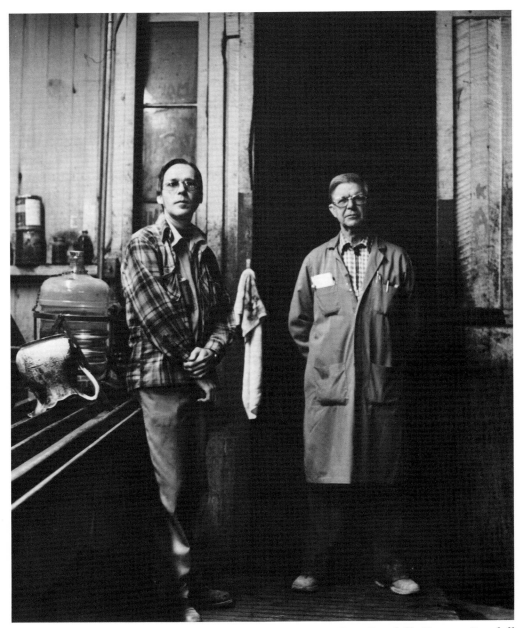

Tom Bendell, George Bendell

58

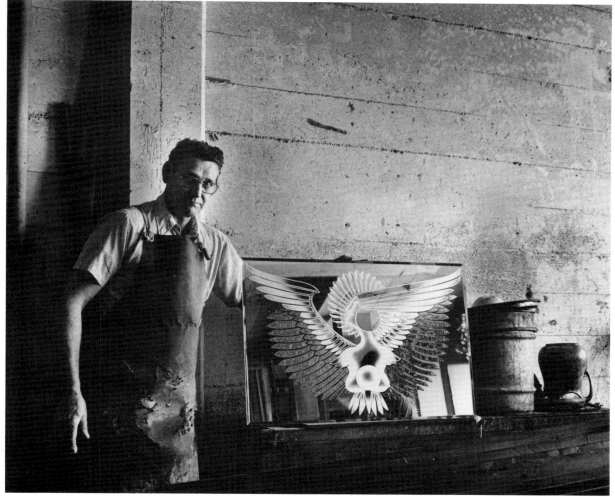

Jack Gren

around now. There's not much opportunity to learn, because there's fewer shops teaching and hiring because of mass production. Make a thousand of 'em instead of two. The assembly line and increased expenses have undermined the old arts. The assembly line really gave people the idea of making a fast buck, and they did, and they still will.

The little things that we all like and want to be able to find and were easy to find, even five years ago, are getting scarce. Say your grandmother's old lamp needs some colored glass put in it. You go to the shop that you know has been there for fifty years and there's a sign on the door: Closed. Where you gonna go now? You don't know anybody else, and maybe he was the last one.

Jack Gren
glass beveler

Seven or eight years ago, I was feeling kind of bored and started working as a glass beveler because I wanted to find out what went on in the craft. I've been working on and off in this shop ever since then.

When I started, I learned the basics of beveling and repairing without too much trouble because I was always pretty good at working with my hands. Although the work came easily to me, even after this length of time I figure I've still got a lot to learn.

60

Mother taught my sister and me how to make lace when we were four years old. She was one of the best lacemakers in Saxony. The dealers would come to her and say, "Let this be made by the good hand."

She learned lacemaking from her mother, who had leaned in what they called a Folk School. It was in the area where our grandparents were born, on the border of Saxony and Bohemia.

The reason we began at such an early age was that our mother worked for money and had to keep us kids busy. She would hang a few bobbins on the back of her pillow, and that's how we started learning. When you learn something as a child, you learn easy.

I was young when World War I was going on, and I remember it was just starvation. It was better not to know what it was we were eating. The first flu epidemic took practically all our generation. The children who were growing up during the war had had almost no nourishment. They would just go away, would die in a week's time. Our mother saved us, and we thank her for it. She found someone with a goat, and she fed us goat's milk and cod liver oil. By golly, she just brought us through.

Lace had always been an industry all through the war, and dealers had been coming to the mountains all along to buy it. But we got nothing much for it. The dealers made the profit. After the war, people wanted to go to the textile factories and make more money. That was in about 1925, and the shipping lines were big customers for table linens and bedding.

Then the trend started that people wanted to migrate to America through the Methodist Church. The preachers came from America and talked to people about going over. My sister, Gertrude, was the first one of the family to go. She was the scout. That was in 1926 and she was twenty-five years old.

After she was there for a while, the rest of the family tried to come, too. Mother and I made the grade, but Dad didn't. The immigration doctors were very strict, and they thought he had rheumatism. What it really was was that Mother had bought him a new pair of wool socks and didn't wash them first. We didn't have good wool yet from after the war, and he

Martha Anderson
lacemaker

got a rash from them. The doctors thought it was some sort of disease, and they weren't letting anyone in who would be without a job because it was the Depression.

I tried again in '34 and went to Berlin and got my visa, but Mother got so sick, got so ill so quick, I couldn't leave then. Gertrude was able to come to Germany in 1936 during the Olympic Games, and I said, "If you don't stay here, I'm going there." I got my visa and went with her back to America.

As soon as we were both here, we worked to get Dad over, too. By that time it was World War II, and he finally got to come over after the war on one of the transport ships that were bringing troops home. Then after twenty-two years we were all together again, except for Mother, who had died.

Lacemaking is in the family blood. Mother always had the desire to go in a foreign country and teach lace, but she never had the opportunity. When Gertrude and I came to America, it was a chance for us to do it. All my life I've made lace, and if I don't do it for a while, it's just like a fever to start again.

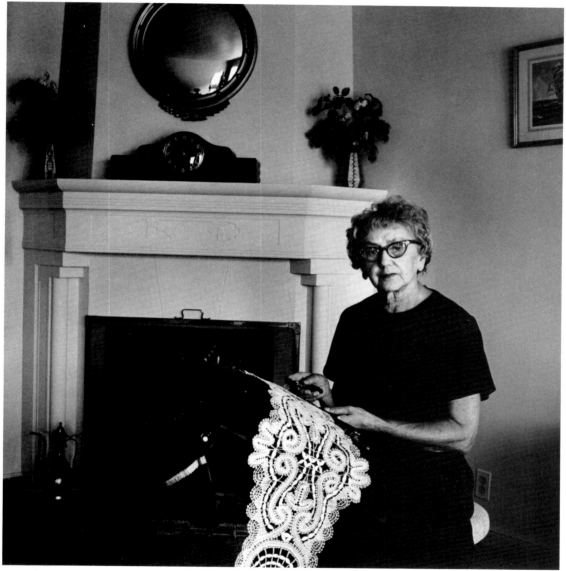

Martha Anderson

Hans Schuberth
bookbinder

In many ways, modern bookbinding is still very close to the way they were doing it in the Middle Ages. We don't often go to the laborious methods of handsewing that they used to, but you still can. My grandfather did. Outside of a slight difference in techniques, the basic handsewing process is exactly the same. Of course, in the large establishments now, machines are used to do a lot of the sewing, and what you have there are essentially machinists. But just in terms of doing the work, I really don't think there would be any problem for a skilled and well-trained modern bookbinder to find himself back in a fifteenth century shop.

In those days they didn't separate the trades of printing and bookbinding. Gutenberg's printing and binding was all done in the shop; so was Caxton's in England. Fifteenth and sixteenth century books were rare and valuable items. The bindings were quite ornate, with diamonds and jewels. It was no longer simply a cover to protect a book or a case to protect a scroll. Most of the printing was theological, and some of the Gothic bindings were particularly fantastic and elaborate. Of course, that's one of the reasons why a lot of them were subsequently destroyed. People would get them and take out the jewels and destroy the books.

Bookbinding has been a family business for 120 years. It started when my grandfather, Frederich Wilhelm Schuberth, decided not to go into the family business and left Leipzig. His people there were music publishers, and my great-grandfather had had a branch of his business here in San Francisco and in New York in 1871. The records disappeared within the year, which means they probably sold out to another firm. But we found a full-page listing for it in a city directory we were restoring for the Wells Fargo History Room. It was quite interesting to find that, because we'd lost track of them ever since my grandfather moved away to start his bookbindery. He was also a musician and a music teacher and had a family of ten boys.

Subsequently, five or six of my uncles went into the bookbinding trade, including my father. Some of them were extremely good, and

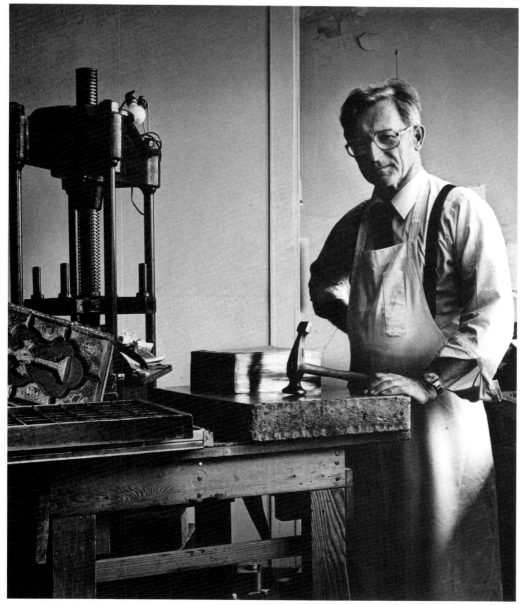

Hans Schuberth

bound for the World Fair exhibits in Russia in the 1890s. After World War I, part of the family went into the allied printing trades. They had a factory in Leipzig. Others of the family continued with the bookbindery. Father was with the paper factory.

When he decided to come to America in 1926, he went back into the bookbinding business. It was probably a financial decision; the paper products would have required a very large capital investment. Because of Germany's big inflation, capital had disappeared or was eroded. So it was by necessity more than anything else, but it was also a trade he knew very well.

He had studied with some of the great masters in Europe. There was a Hungarian man who was the outstanding teacher of the trade of marbled papers. They're made by a transfer-type process in which you put colors in a large tray that contains cooked Irish moss, like a jelly. You put your color combinations down and take combs and make patterns. Then you lay on the book, and the patterns transfer off onto the paper or leather. When this man came through to sell the dyes, they set up clinics. My grandfather made room for him in the shop, and all the apprentices in the city came. Father assisted him. Unfortunately, when we established the business we didn't have time to play around with marbling, so in all these years I personally never was exposed to it. It's a shame. There would be enough time if there were clients who were interested enough in it to pay for it. But you're not just a dedicated artist trying to create something; you're also trying to make a living.

It's a pity that in a metropolitan area like San Francisco which used to be a great printing center—well, it still is to a degree, but much of the work is going out of town—neither industry nor labor has seen fit to establish a real training program for their apprentices. They learn the mechanics in their programs, but not the overall background necessary to be objective about what really should be done. And the artistic aspects have been eliminated. The only ones who still do it the quality way are the amateurs who are going into the field professionally.

But they're doing it the hard way by reading books, so they don't learn to work on a rational basis. Things take three, four, five times as long as they should, and they have to charge high prices which aren't justified, but are necessary from their standpoint.

Of course this is a problem America has had now for a while with most of the trades and crafts. The basic problem is that our educational system has, in my opinion, been much too concerned with academic training instead of teaching people how to get along in the world and become productive, useful members. If you have an academic bent, you can still follow it, but why not learn a trade and learn it properly so you can contribute to your happiness and have stability that's better than a bank account. If you learn a trade at an early age, you never lose it. The training of the individual should be such that we have some objective

standards of quality. It would help offset the feeling that things are going downhill.

When I was about fifteen, I studied with my uncle in Leipzig on special things like gold work. That was very pleasant. But professionally, I didn't get into it until later. When Father established the bindery in Iowa in 1940, I joined him in the business and studied at the university. Then the war came, and after it, I spent several years at the university in Seattle. I was interested in going to medical school, but the timing made it difficult, and there were many other factors also, and I just didn't. It was logical that I simply went back to a business that I knew. Which comes back to my earlier point, that if you learn a trade when you're young and things don't work out exactly as you want them to, you do have something to fall back on.

I graduated from the university, and in the meantime Father had moved to San Francisco and re-established the bindery. We started where the IBM building is now and have moved four times, not by choice. Of course we expanded each time. The first locations were very modest. Now that I'm buying a building, I assume that we will be making our last move.

It's been a long, hard struggle and I'm sorry it took so long to develop to the stage where we are now. In the past, bookbinding has not been one of the more lucrative trades. The people who came from Europe who formed the backbone of the skilled trades were, generally speaking, taken advantage of. They were kept down and exploited by the American competitive system. I'm talking about forty years ago, and conditions were much more difficult then than now. I wish my parents were here to see the development of the business. Unfortunately the good development is not contingent on the artistic aspects. The fine arts really suffered for a while, but I think we're having quite a comeback. Now the only problem is getting the expertise back among the people.

This is a good trade. It's a tremendous outlet for you because you can be creative, and you see the end product. You create a complete unit, and that is very, very rewarding and good. You see exactly where you do well and don't do so well, and you correct yourself. When you're through, you have something you're proud of, and you also make someone else happy.

Through the years, you become much more tied to the business, of necessity and through interest. I think I was more aloof from it in the beginning. I simply get more interested and more appreciative of it all the time.

Bill Zarevich
silver plater

Johnson Plating Works is a general job shop, and anything and everything comes in. Antiques, silver bowls, anodizing. The day goes real fast and you don't have enough time to do everything. It's a challenge, always something different.

Most of my life I've been in jobbing. You get a wide range of work: soft metals, pewter, brass, copper. There are a lot of men who can't come in this kind of shop, because they know one type of work and that's it. Same work day after day. Christ, it'd drive me nuts.

I've been in the trade forty years. When I was seventeen, an old polisher, who's been dead for years now, took a liking to me. He was just working by himself in a little shop and needed some help. He taught me the fundamentals of the trade, gave me the right start and the right way of doing things. There is damn near always one guy in this craft who takes an apprentice and starts showing him how to do stuff. I taught an apprentice class myself for a couple of years and had twenty-four boys. You can tell the ones who are gonna be good.

I've never drawn unemployment in my life, and I've always been working steady. If you know the business you can pick up a job, and could even during the Depression. Then you'd work a few days at a time and things were tight, but you could count on making a couple of bucks. None of the guys I knew were in the breadlines. It was rough times, I'll guarantee you that, but we made out okay.

Looking back over forty years in the trade I can say it was interesting, and it's still interesting. You gotta love the work to do it. If you hate it, you think it's dirty and unhealthy. It is dirty and unhealthy work, but what the hell you gonna do about that?

I always like nice stuff and like to see if I can get things to come out perfect. You do the work the way you'd do it if the thing was for your own home, and then what really makes your day is when the customer sees it and goes ape. Then you feel good.

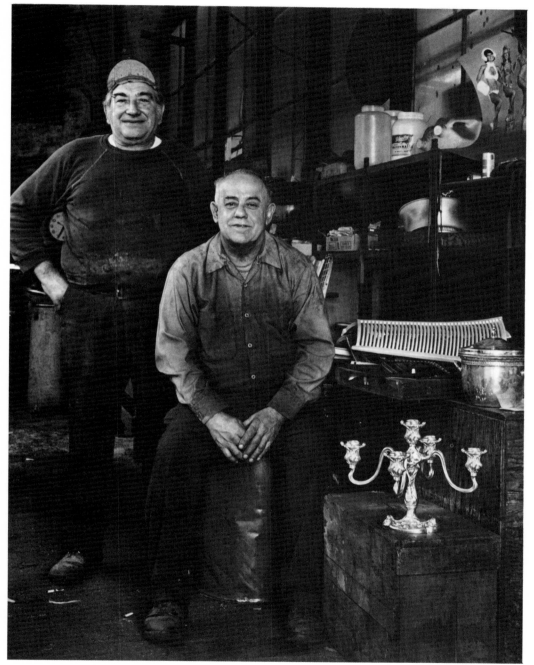

Frank Feola, Bill Zarevich

Bill Mork
sheet metal worker

My grandfather, Walter Mork, Sr., learned the sheet metal trade in Finland and brought his skills with him when he came to the United States. He settled in San Francisco and started working in sheet metal shops, and then opened his own shop in West Berkeley in 1911.

Walter Jr., my dad, joined the business at about the age of fourteen, and his brother Ewald also started early in his life. They all worked together and had a pretty large and successful business. They were manufacturing gas furnaces up until the Depression when things started slowing down. There are still quite a few of their furnaces in the old houses in Berkeley.

When World War II began my grandfather became a sheet metal instructor at the ship yards. There were a lot of men from farms and small towns working there who needed to learn how to work with metal in order to help build the ships for the Navy. My father and uncle also worked at the ship yards as sheet metal mechanics. After the war was over my dad and grandfather returned to the shop, bought some equipment and started up production again. My uncle moved to Santa Rosa and became a chicken farmer.

When we were kids my dad used to bring my brother Fred and me down to the shop. He taught us simple things like soldering, arc welding, and how to use tools. When Fred got older he did an apprenticeship at Laney College and joined the business in 1969. I did my apprenticeship and joined them in 1974. Since my dad retired and now has passed away, my brother and I are running the business.

To do well in this trade it helps if you have some natural mechanical aptitude and the ability to visualize three-dimensional spatial relationships. These two traits seem to run in our family. I feel that this trade is going to be with me as long as I live and that I couldn't forget it even if I tried.

Walter Mork

Mario Martello
instrument builder

Jazz is what made me interested in building instruments. I used to make cabinets in my father's shop in Argentina, and later I made fine furniture. Then I turned to musical instruments because I started to learn guitar with one of the famous jazz guitarists in Argentina.

My first one was made cheaply with plywood, and pressed with a mold. It was not really the finest. The finest is all carved wood. The guitar turned out pretty good, and it sounded fair enough for a plywood guitar. People liked it, and some bought it because over there that kind of jazz-style instrument was not too popular and was hard to find. I made a few hand-carved ones, too, but couldn't get good wood for them. You need rosewood, spruce and mahogany and that wood is very scarce over there.

Then I came into this country in 1957 and tried to work with the guitar maker D'Angelico in New York. He didn't need anybody. I tried in other musical instrument factories, and they didn't need anybody, either. So I worked in furniture, which was my trade.

A couple of years later, I came into California. You know how everyone tells you about California. I started working at Dependable Furniture, again in my trade. After a few months, from a friend, I got work at Acoma Music, working in the repair shop. You can imagine it felt very good to get out of the furniture business and back to music. When you work in your hobby it's like being with a girl you love; it's different from the other girls.

Everything started from the seven years working there. For a long time I'd been thinking about having a shop in my home, and now that's how it is. I do repairs for many places and have all the work I can do. And some time to build instruments.

Andres Segovia, John Stewart and Charlie Byrd all have guitars "by Mario." I remember some advice Segovia gave me. He said, "It depends on the music. If you play before ten people you need a different guitar that doesn't project as much."

It's also very important to know just what type of wood to use and where to use it when you're building an instrument. For making and repairing instruments, I use both the skill I learned in the old shops in Argentina and the advice I've gotten from the guitar masters I have known.

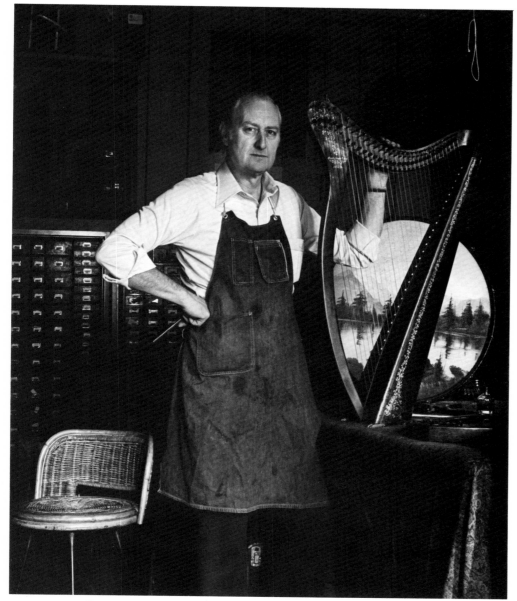

Mario Martello

Jerry Cavanaugh
blade sharpener

My father was a carpenter, and in them days they used to do their own work on their saws. I remember as a boy I used to watch my father sharpening his tools. He'd sit there with a file, and it'd take him about half an hour to sharpen a saw. Nowadays, the machine makes a pass down the length of the blade and does it in five minutes.

I worked awhile with him in his cabinet shop when I was young and right out of high school. But that was about when the Depression days were comin' on, and things were getting bad, and work was slowing up. He finally closed the shop and worked odd jobs. So I joined the Navy, and stayed there.

I've been here in the saw works now about thirteen years, ever since I retired out of the Navy. I kinda like it, and I'll probably finish up here. A lot of the old work isn't around much anymore. Tools are getting replaced. Now we're seeing the carbide saws, which you never used to see. And that's even built up just since I've been here. The big shops are using them a lot. They're pretty expensive, but they stay sharp a lot longer and will cut metal.

The smaller shops run by the old-timers are still using the old saws. They say there was better steel in the old ones. Even my dad used to say he remembered back when they put better steel in the tools. That was forty, fifty years ago. I wonder what he'd think now.

74

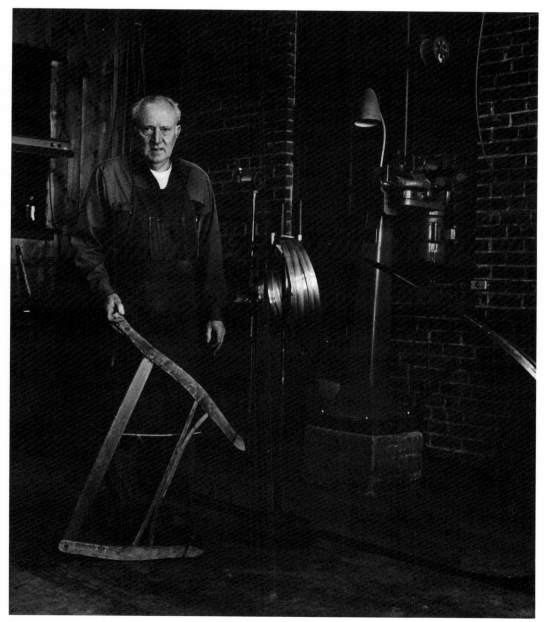

Jerry Cavanaugh

Carl DeAgostino
stonecutter

Rumania is the country I come from, and we lived in a small town on the Danube near the Yugoslavian border. My father had a stone-cutting shop and was partners with my brother. I've been doing this kind of work since I started with them when I was fourteen years old. The work was in the home environment, and little by little you started. It's like inheriting something from your parents.

Back then in Rumania, they were not equipped like we are now. Almost everything you had to do by hand. They have here machines to do it. For cutting marble, for example, we have compressors with pneumatic hammers. There, we did it all by hand hammer. We had hammers with teeth that we used to cut slabs of marble eight inches thick. We also made our own tools, because it was very expensive to have them made by someone else. We did everything; we managed it.

When we had to cut the big slabs from a block of marble we started early in the morning. We had a saw with a thick blade, four inches high, ten feet long. Two of us had to push and to pull, little by little, with another person on top of the block to put on water and carborundum. It was very hot in the summertime in Rumania, and it took sometimes eight hours to cut one slab. Very hard.

Besides myself, my father and brother, there were four or five workers. Wages were low, but life was active. People liked very much the stones, and they didn't care about money when they ordered a stone. They had a strong religious feeling and appreciated art, too, and they ordered big jobs. We were very busy. My brother was a good worker, and honest, and the job was 100 percent guaranteed. We had customers from other towns and the countryside. People didn't have too much money sometimes, but they paid with food. They gave you a pig, sacks with grain, cheese. Since they had no money, it was the only way to pay.

I also worked for many years in Italy. And then I got to the United States in 1968, and started working here for Bocci. But I was already skilled; I was able. In Italy my job was making statues, sculpture, decorations. I liked making these things. It's different work. You are creating

76

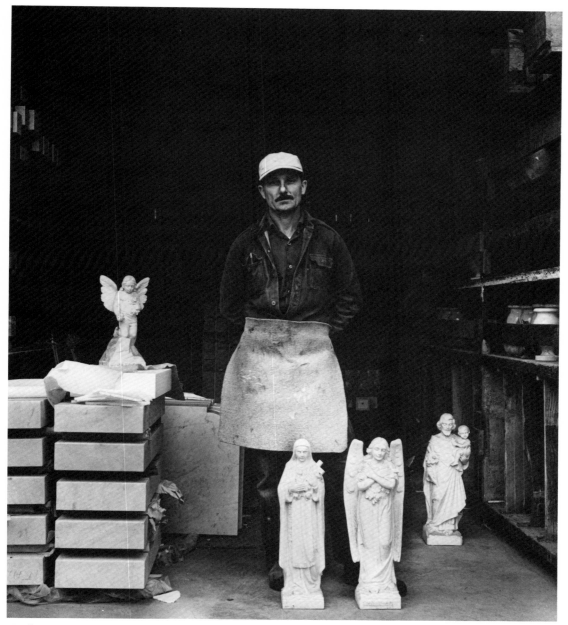

Carl DeAgostino

and feel more joy. But then here, I changed work a little. Most statues are imported from Italy, and I very seldom do them now. Instead I do hand-carved lettering and match up old lettering styles on old stones.

I had to learn to work with granite when I came to this country because they didn't make granite monuments in Rumania or Italy. They used Carrara marble, and it's much softer than granite. To work with granite you need to use tools of very hard steel to make a mark. You get to know the stones after a while.

If I'd stayed in Rumania it would be very hard. The Communist regime makes it different. There used to be lots of well-to-do people who would order the big jobs. Now they can't afford it. If I'd stayed, today I would probably be working in a State-owned shop. Now almost everybody works for the State, even barbers. The wages are very low, and the incentive is lost. The feeling is different because you are exploited too much.

Appendix

Locations of the Artisans' Shops

Antonio Andreatta
De Bella's Barrel Factory
1176 Harrison Street
San Francisco, California 94103

Frank Passa
Violin and Bowmaker
140 Geary Street
San Francisco, California 94108

Herman Campana
William Campana and Sons Retinning
162 Clara Street
San Francisco, California 94107

Helen Weinschenk
The Wooden Heel
3985 24th Street
San Francisco, California 94114

Andrew Fisher
Simpson and Fisher Marine Canvas
240 Steuart Street
San Francisco, California 94105

Virgil Antolini
Costa Ornamental Iron Works
47 Juniper Street
San Francisco, California 94103

Louis Ravizza
Art Tool and Die Works
1014 60th Street
Oakland, California 94608

Harvey Egbert
Biro and Sons Silversmiths
165 Fell Street
San Francisco, California 94102

Roy Haver
Venetian Marble Company
991 Harrison Street
San Francisco, California 94107

John Lukas
Church Art Glass Studio
152 Helena Street
San Francisco, California 94124

Raymond Rio
American Electro Finishing
4933 San Leandro Street
Oakland, California 94601

Lawrence Fambrini
Phoenix Day Company
51 Washburn Street
San Francisco, California 94103

Paul Busch
Starr Saddle Shop
410 7th Street
Oakland, California 94607

Morello Wireworks
Closed

Valentina Tailoring
Closed

Duke Cataluna
Merritt Fabrication
1020 54th Avenue
Oakland, California 94601

Tom Bendell
Bendell and Company Glass
176 11th Street
Oakland, California 94607

Martha Anderson
Lacemaker
Atherton, California

Hans Schuberth
The Schuberth Bindery
589 Bryant Street
San Francisco, California 94107

Bill Zarevich
Johnson Plating Works Inc.
2526 Telegraph Avenue
Oakland, California 94612

Walter Mork Company, Inc.
844 University Avenue
Berkeley, California 94710

Mario Martello Instruments
4621 Lincoln Drive
Concord, California 94521

Jerry Cavanaugh
Standard Saw Works Inc.
181 10th Street
Oakland, California 94607

Carl DeAgostino
Bocci and Sons Monuments
7778 Mission Street
Colma, California 94014

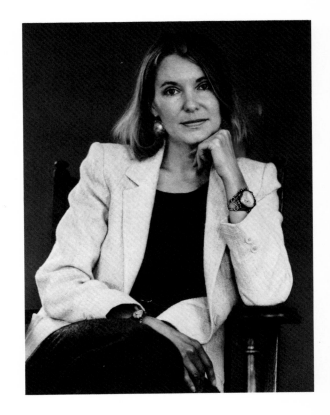

Barbara Traisman was born in Chicago, Illinois, in 1945, where she spent the early part of her childhood. Her family later moved to Madison, Wisconsin. She graduated from the University of Wisconsin with a degree in English literature. Before becoming a photographer, she taught high school English and worked as a copywriter for a publishing house. In 1971 she moved to California and now lives in Berkeley. She is currently in the midst of a new body of work.

About the Author

$12.95
ISBN 0-916860-07-8

cb

Carolyn Bean Publishing, Ltd.
120 Second Street
San Francisco, California 94105